tiny gratitudes

BROOKE ROTHSHANK

**PARALLAX
PRESS**

BERKELEY, CALIFORNIA

Parallax Press
P.O. Box 7355
Berkeley, CA 94707
parallax.org

Parallax Press is the publishing division of *Plum Village Community* of *Engaged Buddhism, Inc.*

Cover and text design by Debbie Berne
Author photograph © Jen Janson

ISBN: 978-1-946764-17-1

1 2 3 4 5 / 18 17 16 15 14

Library of Congress Cataloging-in-Publication Data

Names: Rothshank, Brooke, artist.
Title: Tiny gratitudes / Brooke Rothshank.
Description: Berkeley, California: Parallax Press, 2018.
Identifiers: LCCN 2018033674 (print) | LCCN 2018034085 (ebook) | ISBN 9781946764188 (Ebook) | ISBN 9781946764171 (paperback)
Subjects: LCSH: Rothshank, Brooke—Themes, motives. | BISAC: ART / Techniques / Painting. | ART / Techniques / Watercolor Painting. | CRAFTS & HOBBIES / Miniatures.
Classification: LCC ND237.R7256 (ebook) | LCC ND237.R7256 A4 2018 (print) | DDC 751.42/2—dc23
LC record available at https://lccn.loc.gov/2018033674

To Layton, Linden, and Bryn,
my gratitude teachers.
And to Justin, for your respect and love.
I am forever grateful.

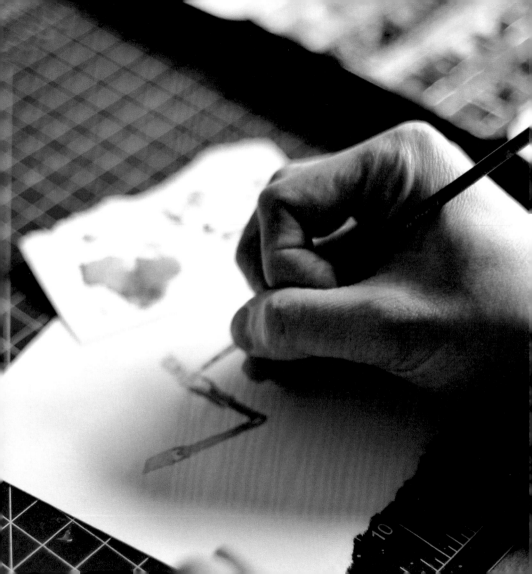

foreword

I paint miniatures. In 2014, I painted one miniature painting a day for a year. It was much like a visual journal. I loved the consistency of this routine and the creative growth that followed.

Two thousand sixteen was a difficult year for my family and included the death of a grandmother and uncle, other close family members in deep personal pain, and the early birth of our third child, resulting in a NICU stay. All of this was against the backdrop of the world's political and environmental turmoil, which felt louder than ever. I was tired in so many ways.

A podcast I had listened to with Brother David Steindl-Rast kept coming back to me. "Can you be grateful for everything?" he asked. "No, not for everything, but in every moment." I then listened to his TED talk where he said, "It's not happiness that makes us grateful. It's gratefulness that makes us happy." I was hungry for these reminders and curious to know more.

I wanted to be more grateful but was not sure how to make it happen when my automatic response to hard times was negative. I wondered what gratitude really meant. If I were able to create feelings of gratefulness by learning to see differently, then gratitude no longer required a brief positive transaction or getting something external that I wanted. I began to think about the spectrum

of gratefulness in my life, from getting new shoes to waking up to a new day.

When so many parts of my life felt out of my control, acknowledging the importance of my perspectives was powerful. It was clear that my response to the unpredictable, rather than the actual circumstance, determined if I lived a life of resilience and joy.

I decided to make a weekly painting based on gratitude to help train my brain to be alert to ways I could be thankful despite the conditions. My husband, Justin, is a potter, and he agreed to create a weekly piece of pottery also inspired by gratitude. Our goal was to cultivate gratefulness in a way that clearly acknowledged difficulty and simultaneously allowed beauty. We planned to post our weekly work on Instagram with the hashtag #rothshankgratitudeproject and to write monthly updates on our progress. Maybe gratitude could be contagious? At least it would be a way to stay accountable.

Collaboration with Justin encouraged a supportive dialogue. It was fun to see when our gratitude overlapped, when we surprised each other with what we saw, and when one of us needed help feeling thankful. It was a reminder to connect with each other over more than the practicalities of work and family life. We hoped it would inspire us to slow our pace and learn to view our everyday lives differently, as a gift. It felt good to be grateful even when it was not easy.

This book is a result of that yearlong project, a collection of weekly moments from 2017 where I found gratitude. It is my own small experiment in what it means to choose grateful living. With three children and our family business, I can't say choosing gratitude relieved what often felt like a hectic schedule. More than once I uttered the words, "I still have to do my gratitude this week!" None of these paintings represents a moment of pure success, joy, or ease. Each one holds the potential to represent a fear, loss, or challenge. All of the feelings remained but the focus was allowed to shift. Learning to adjust perceptions that had become habit strengthened my ability to hope.

Hope, the kind that accepts what is true or unknowable while being open to what is possible, was a byproduct of this gratitude project. I found that processing what happened in my days with a gratitude filter required that I be hopeful. In Krista Tippet's book *Becoming Wise*, she says, "Hope, like every virtue, is a choice that becomes a habit that becomes spiritual muscle memory. It's a renewable resource for moving through life as it is, not as we wish it to be."

Each one of the fifty-two paintings that I posted on Instagram felt as if it were an individual work of art. I recorded the day and time of each painting along with notes on where I found gratitude. Having all of these micro moments together now creates a new macro work of art. It highlights the value of a committed practice and is for me a reminder that the small decisions we make daily add up to the experience of life.

I'm still learning what it means to allow unconditional gratitude to lead. I want to value what I have now and open my eyes to everyday opportunities instead of waiting for impossibly perfect conditions to experience gratefulness.

If nothing else, practicing gratitude has taught me to be more gracious with myself and others. Being grateful does not result in an easy life. It does allow me to relax in the knowledge that things will sometimes go wrong. That is unpreventable but it is not the end of everything. Even knowing that I will sometimes fail at finding ways to be grateful is somehow reassuring. Accepting that as inevitable means it's more about the trying than the outcome. Looking back over a year of striving for gratitude, I can see more clearly how singular mistakes and failures matter less than the big picture effort to persist in a positive direction. I will mess up. When I slip, I will be grateful for the chance to try again.

I hope these pages will delight and inspire you to uncover your own tiny gratitudes.

B Rottershank

I am grateful for . . .

time to dream
looking forward
collective hope

January 1, 2:45 pm

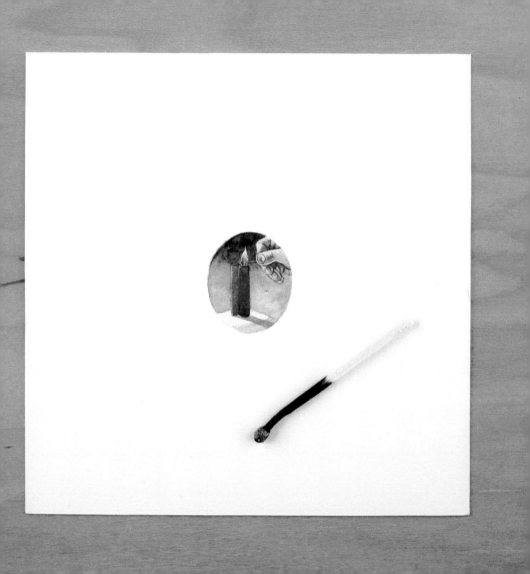

family heirlooms
my past informing my present
accepting the passage of time

January 10, 3:52 pm

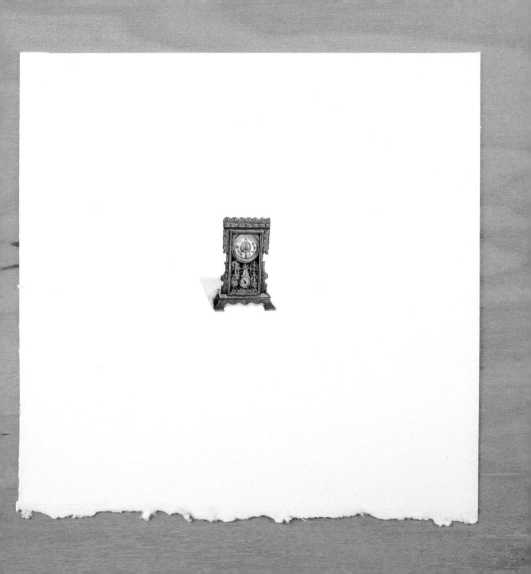

working with what we have
glasses half full
being accepted as we are

January 19, 2:45 pm

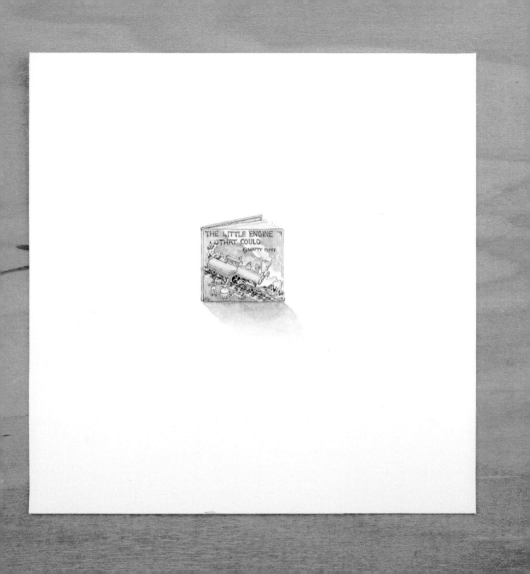

gestational first birthdays
her strength
hitting milestones

January 24, 2:15 pm

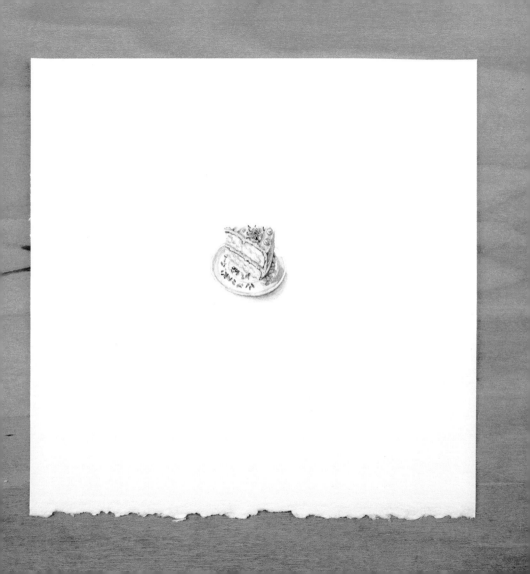

health care
precautions
available resources

January 31, 2:25 pm

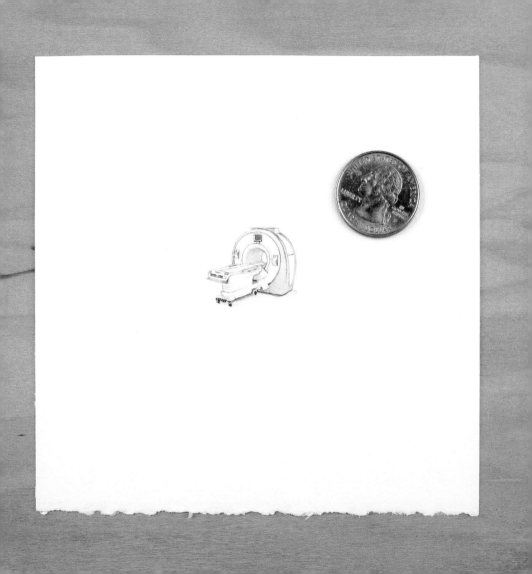

drawing close
needing each other
healing touch

February 7, 2:17 pm

one who likes spicy
one who likes mild
one who likes plain

February 15, 3:42 pm

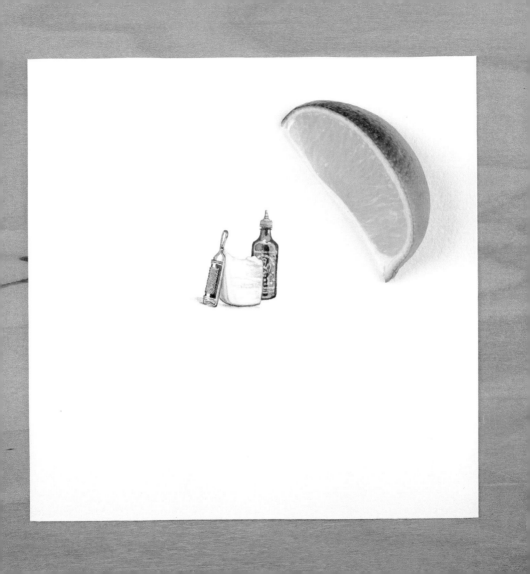

recovering from the flu
quiet moments before the day starts
longer days

February 20, 11:54 am

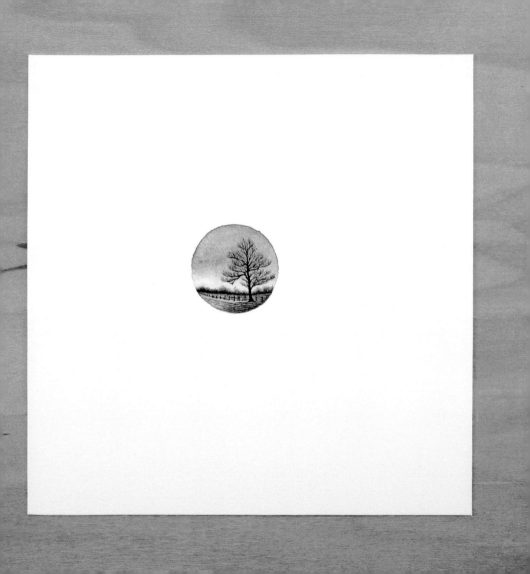

free to be you and me
dancing with a one-year-old
screen-free activities

February 28, 2:38 pm

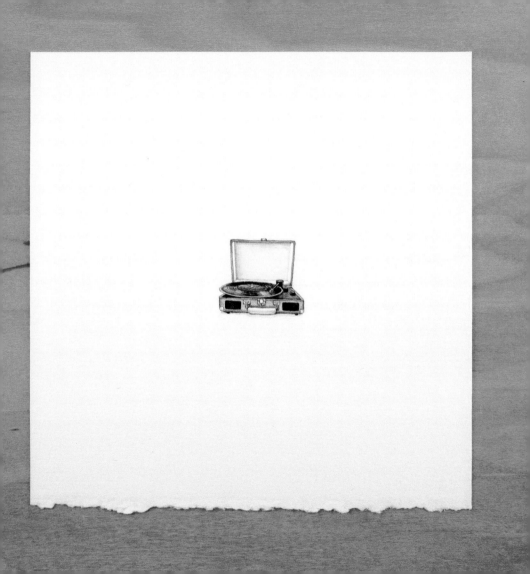

sharing what we love
unexpected treasures
being known

March 9, 3:04 pm

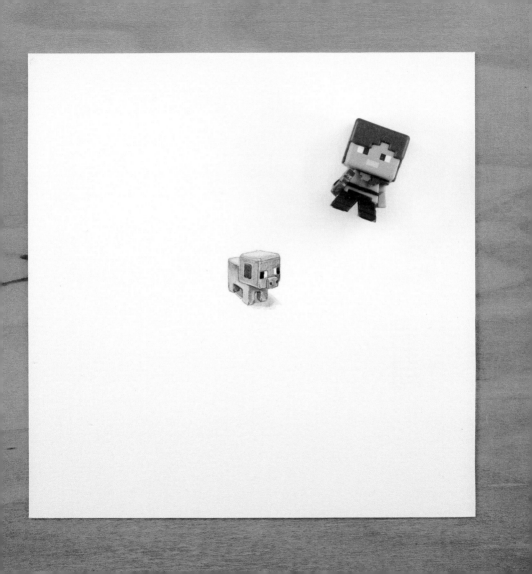

fine motor skills
simple songs
tenacity

March 16, 2:43 pm

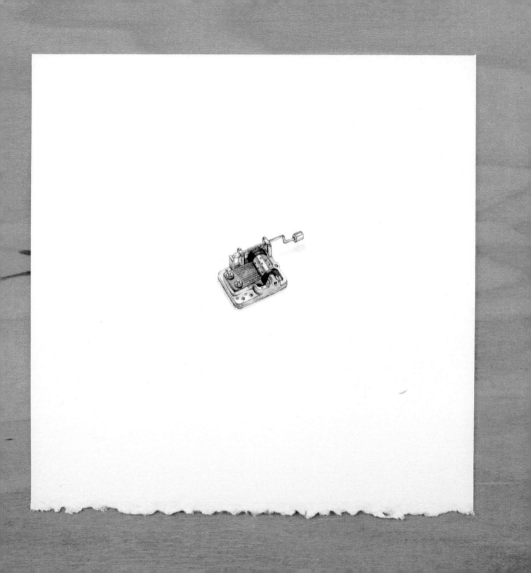

morning sun
light in darkness
beauty in shadows

March 23, 11:47 am

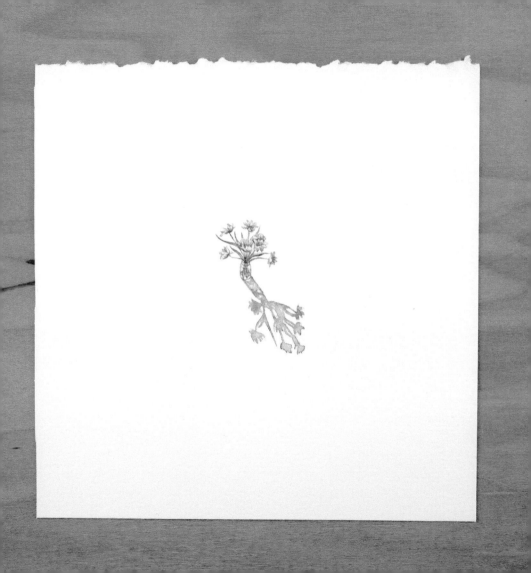

companionship on walks
persistent affection
purrs

March 29, 1:45 pm

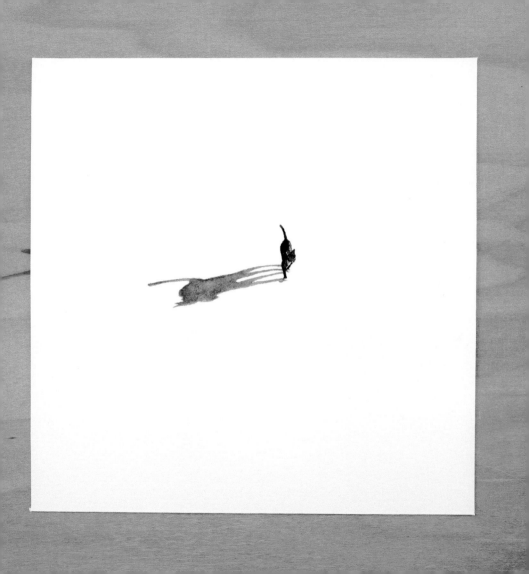

Miami traditions
breakfast on the beach
seagulls from a distance

April 3, 3:40 pm

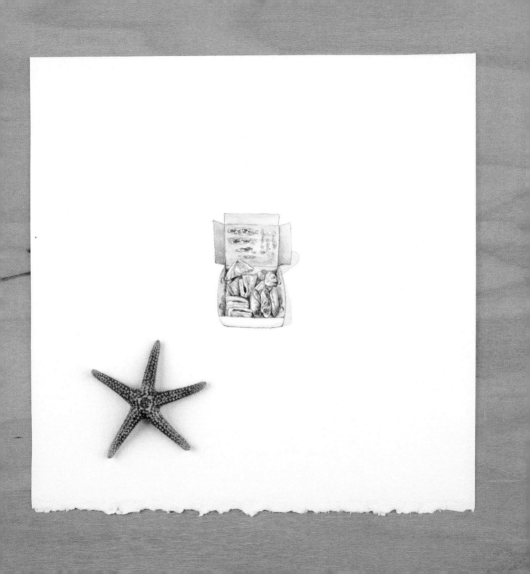

the smell starting to fade
cleaning supplies
a new fridge

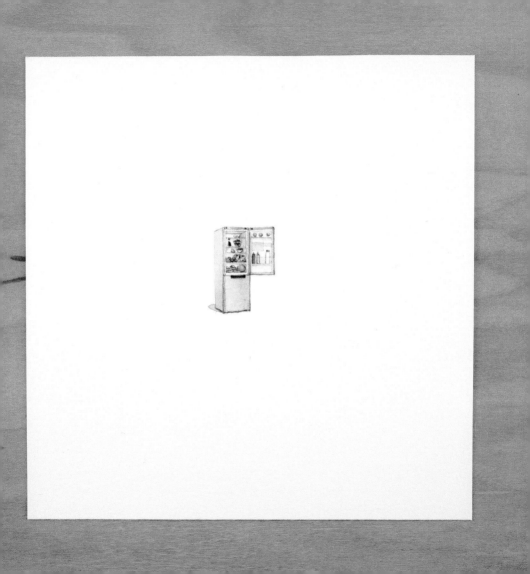

dedication to nonviolence
peace in action
role models

April 19, 10:52 am

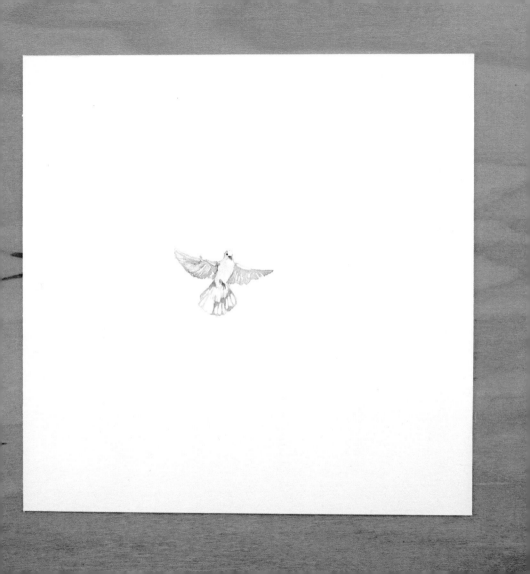

healing
caregivers
patient support

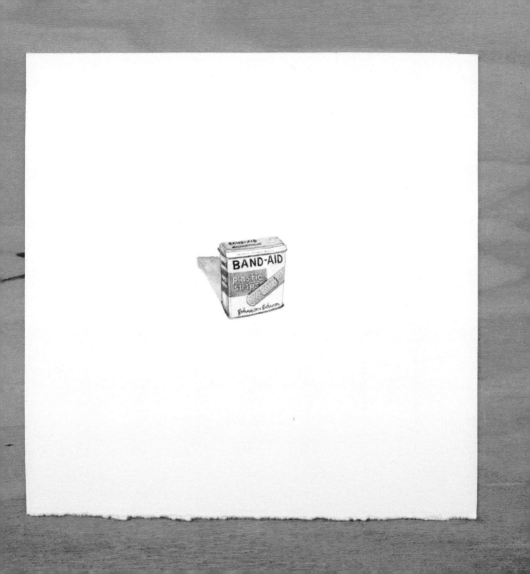

running hard and laughing harder
teammates
passions

May 3, 3:27 pm

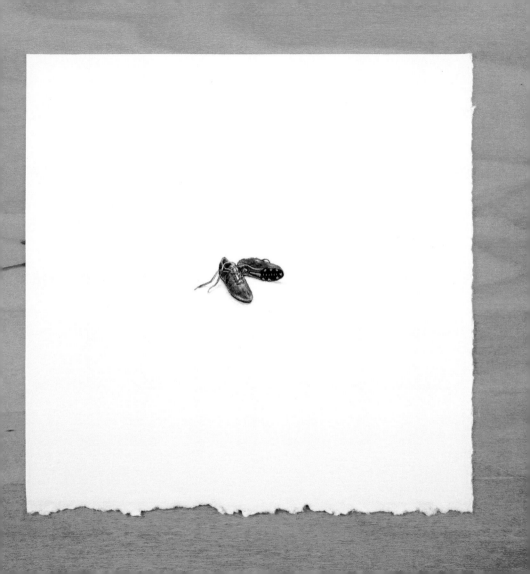

gross motor progress
gentle instruction
play therapy

May 11, 2:29 pm

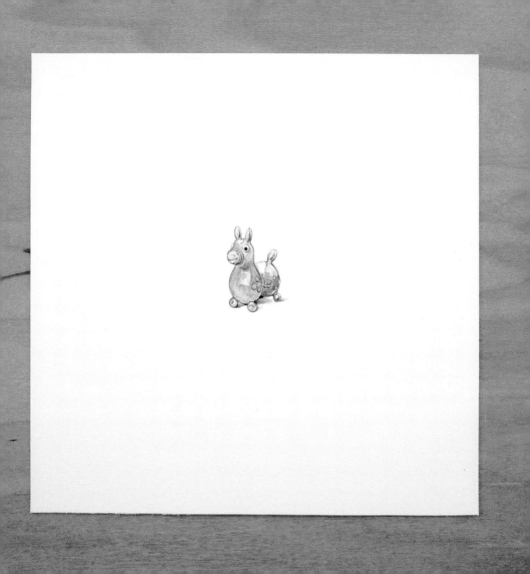

shared stories
intergenerational friendships
people who dance to their own beat

May 18, 1:41 pm

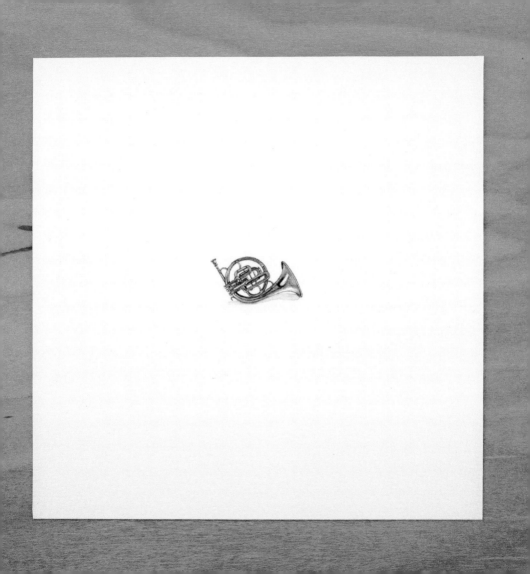

gentle adjustments
full mobility
holding my children without pain

May 23, 1:18 pm

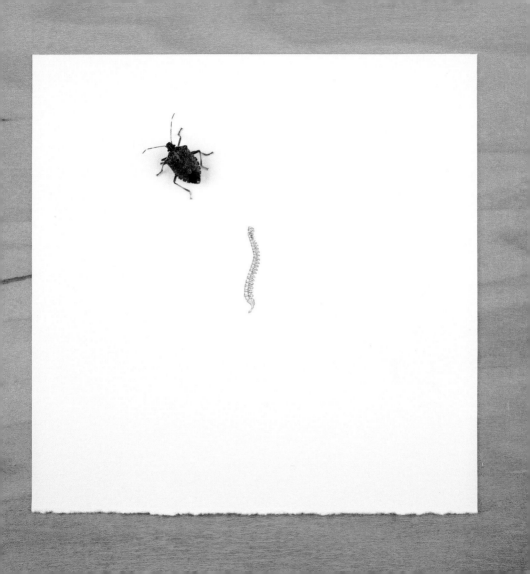

the start of summer
backyard camping
no one catching on fire

June 1, 9:04 am

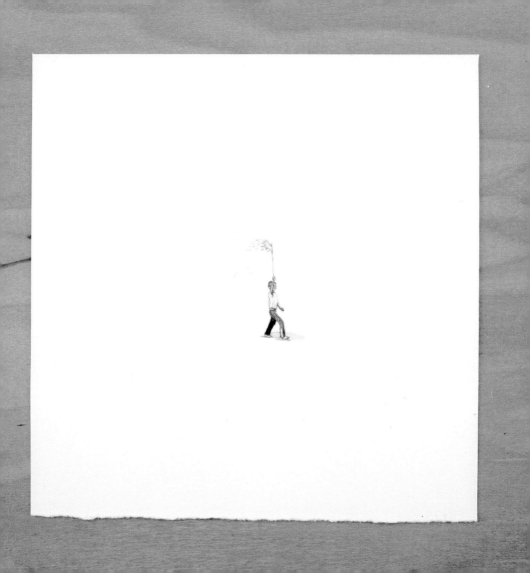

fifteen years together
all our collaborations
partnership that allows growth

June 8, 11:54 am

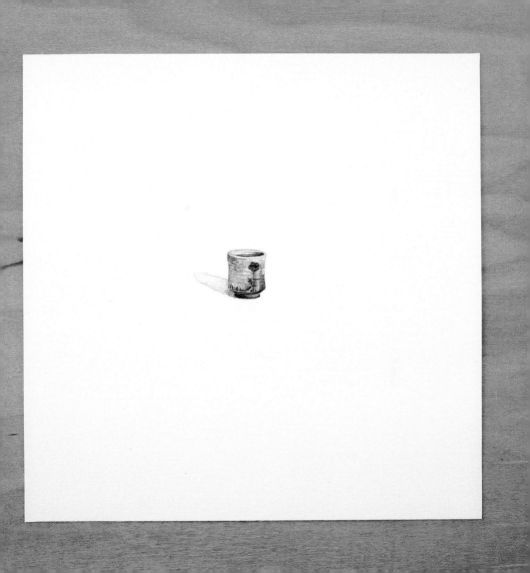

time with just the two of us
his love of chicken pakora
a four-year-old's questions and ideas

June 13, 2:12 pm

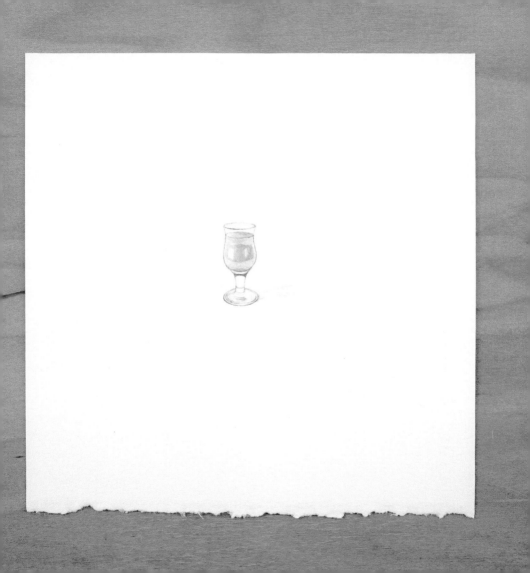

something we all enjoy
shared Popsicles and space
friends who are family

June 21, 9:34 am

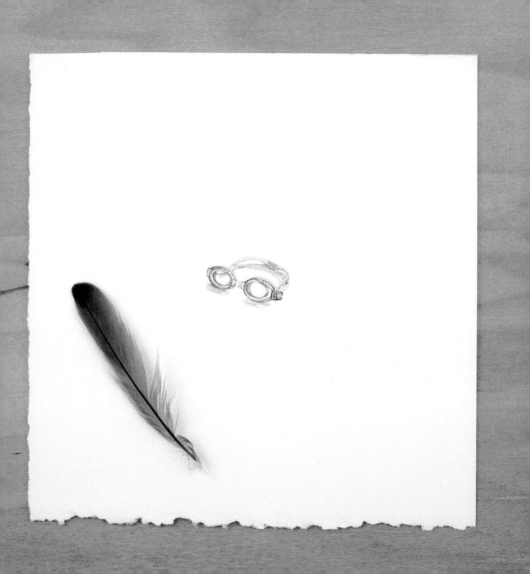

away space
an organized place to work
the quiet

June 29, 11:17 am

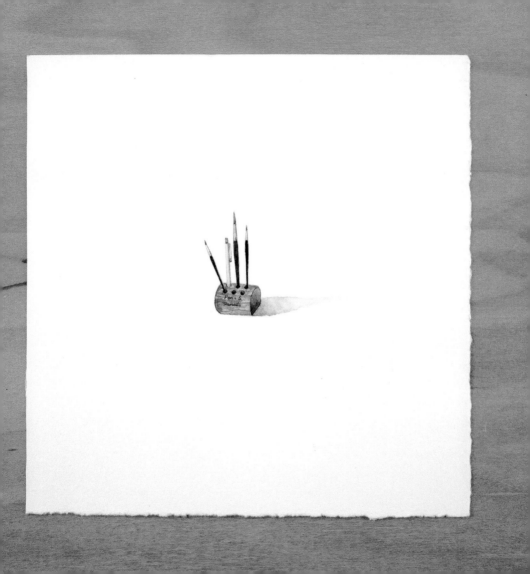

fresh food
filling the freezer
memories of my grandmothers

July 6, 3:25 pm

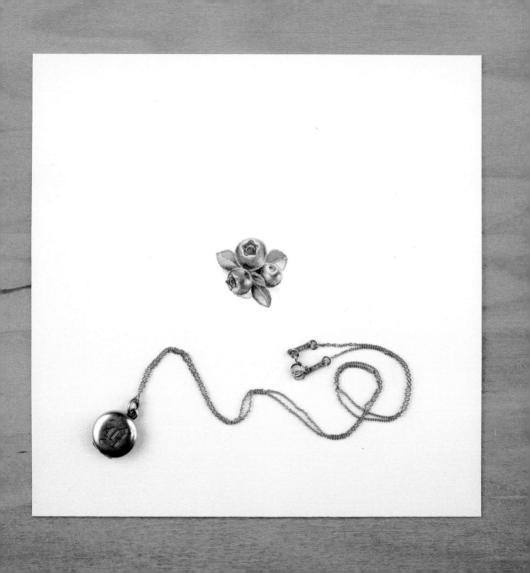

local treats
a place to gather with friends
plenty of napkins

July 11, 10:17 am

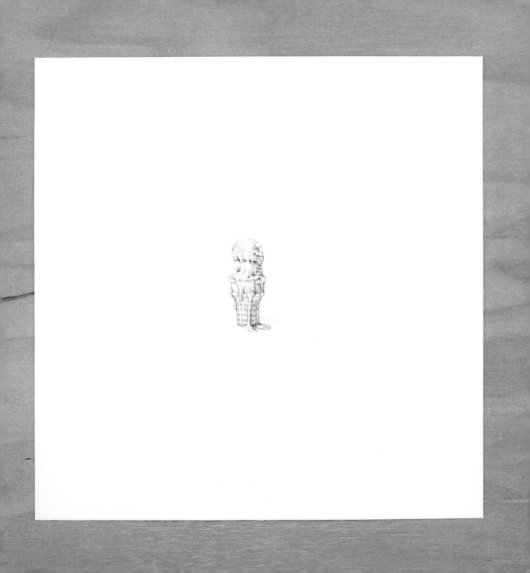

first steps
how far she's come since the hospital
her being

July 20, 1:22 pm

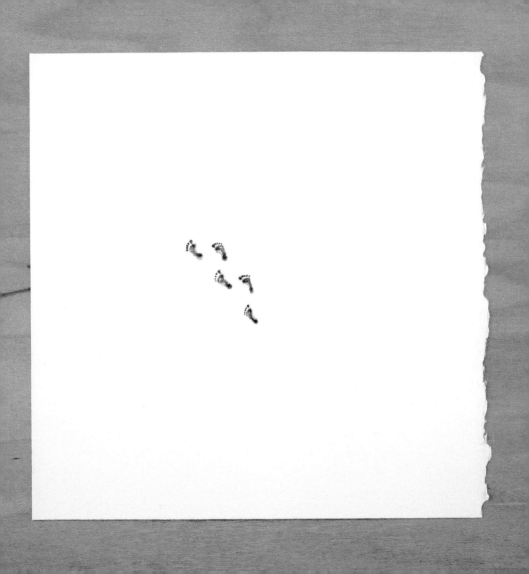

family giggles
black-and-white photos
Steel City fun

July 24, 3:12 pm

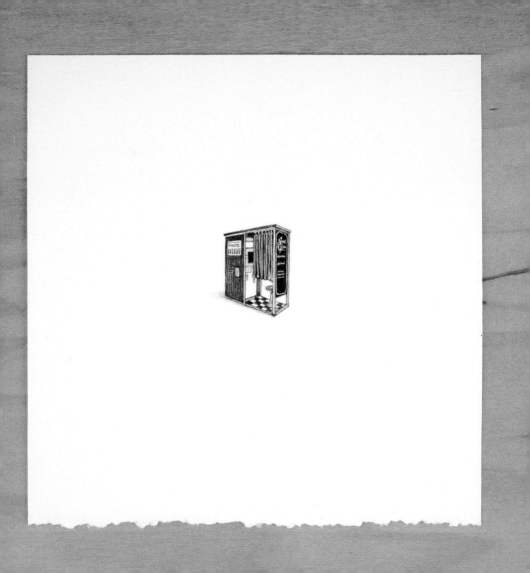

color, fragrance, and flavor
garnishes and bouquets
low-maintenance plants

August 4, 1:30 pm

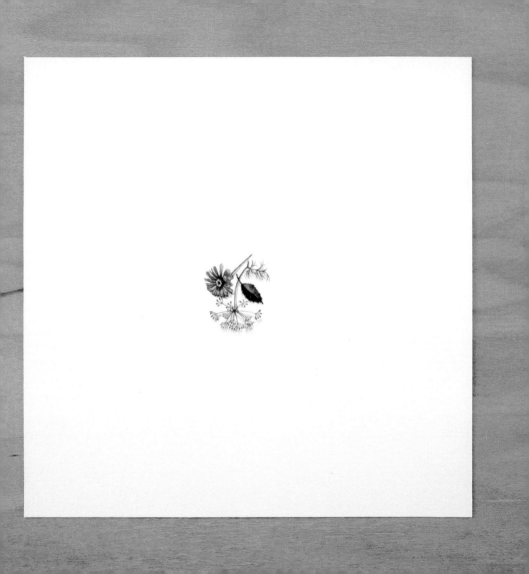

thoughtful neighbors
Verna's generous pie habit
learning to receive

August 7, 1:23 pm

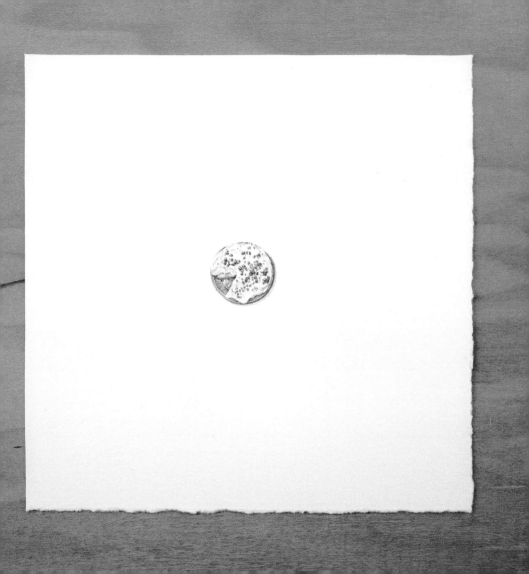

a five-year-old's enthusiasm
the difference each person can make
light in darkness

August 14, 2:38 pm

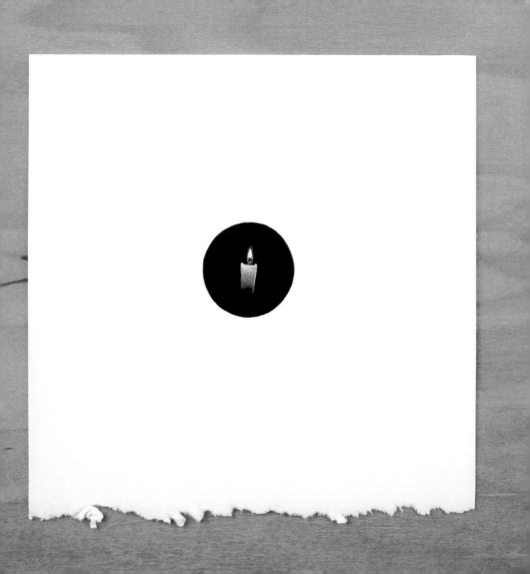

a time to pause and wonder
a break from negative news
a universal experience

August 22, 2:24 pm

Please send in this card to receive a copy of our catalog. Add your email address to sign up for our monthly newsletter.

Please print

Name_____

Address _____

City_____ State _____ Zip _____

Country_____

Email _____

PARALLAX PRESS
P.O. Box 7355
Berkeley, CA
94707

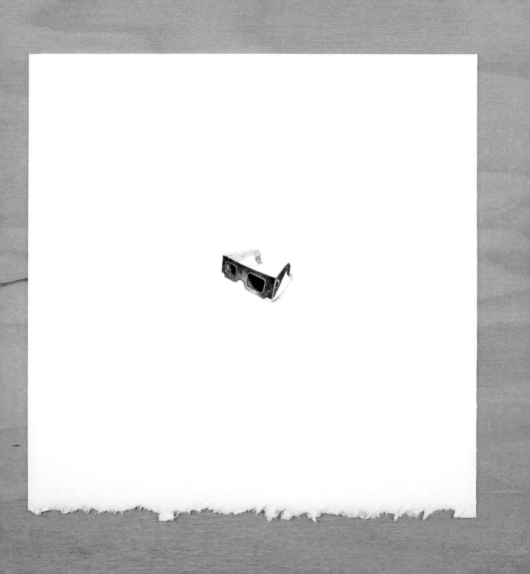

new life
shared journeys
deep love despite loss

August 27, 4:49 pm

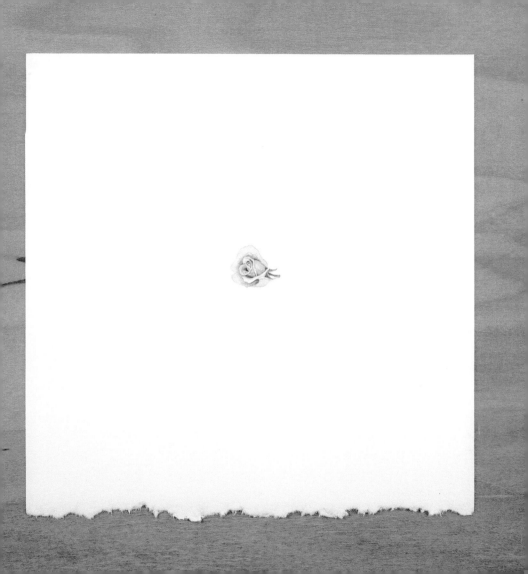

imaginative play
everyone getting along
no sand in their eyes

September 6, 9:35 am

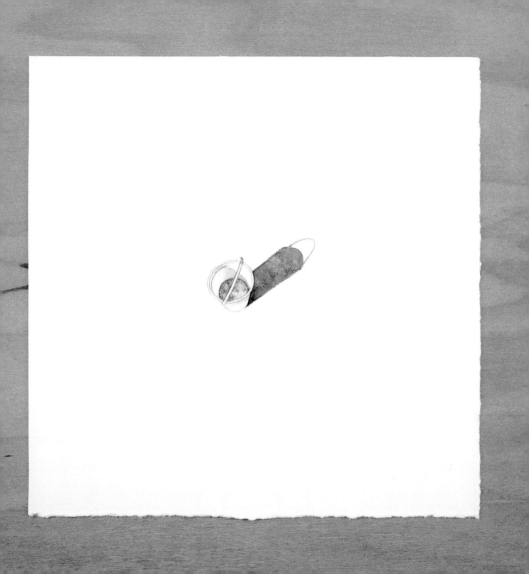

growing up together
memories
being welcome and known

September 10, 11:24 am

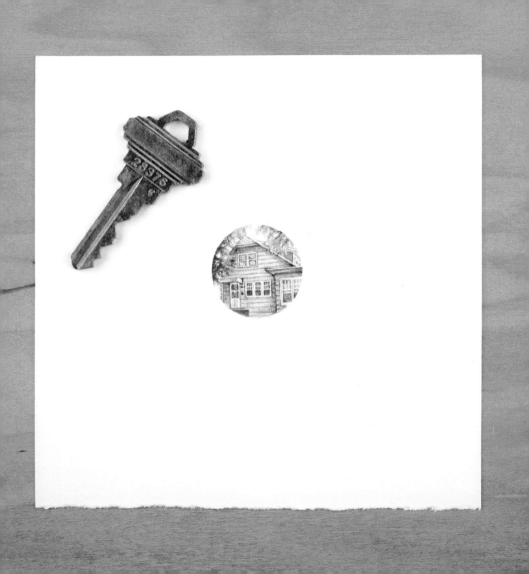

helpers on Sunday night
AAA
fitting in the truck cab

September 18, 1:20 pm

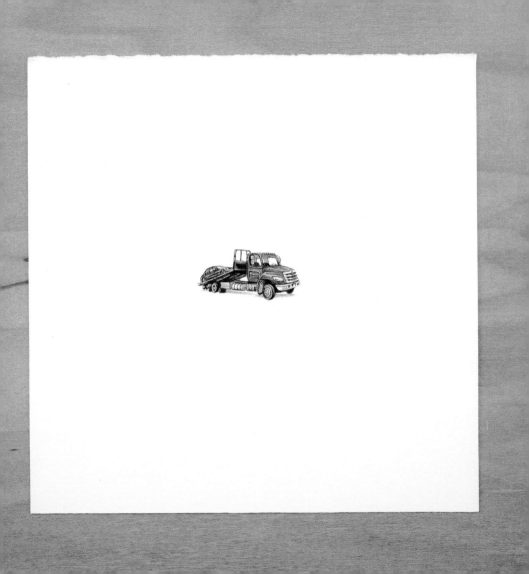

working electricity
cold drinks
relief from the heat

September 28, 11:15 am

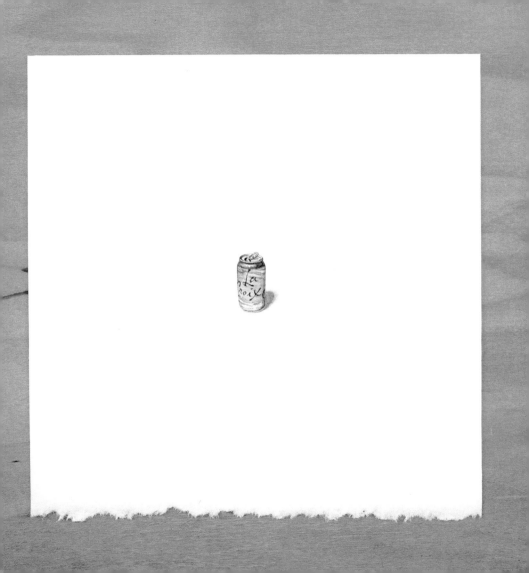

medicine
no more fever
catching up on rest

October 5, 9:20 am

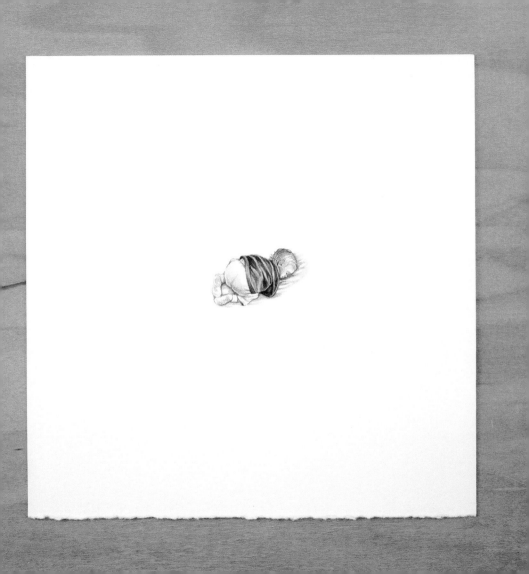

ethical inventors
service-led living
a curious and creative father

October 11, 12:44 pm

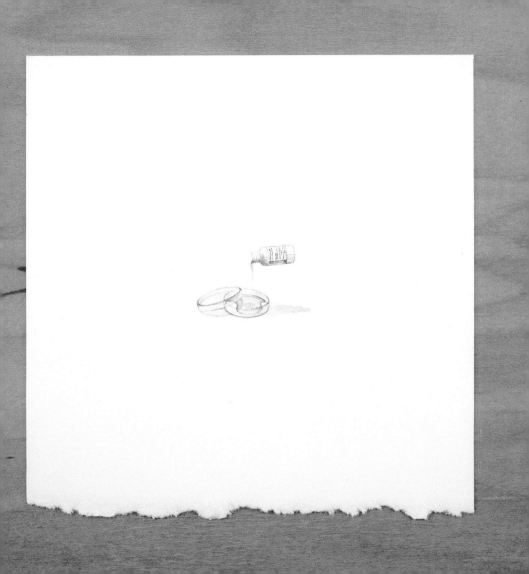

sunshine
shared experiences
waterslides

October 16, 12:44 pm

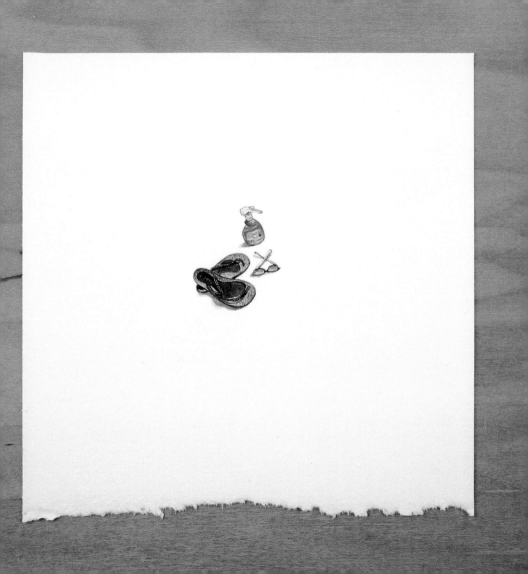

my neighborhood
a peace-loving community
reminders to slow down

October 22, 9:25 am

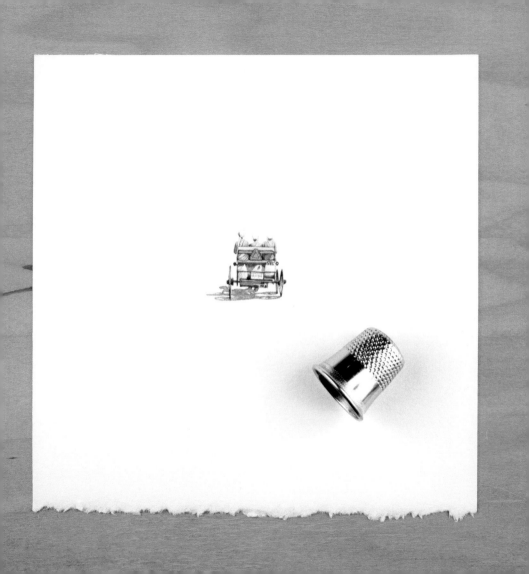

knowing everyone spills
learning people matter most
my mother's example

November 2, 1:06 pm

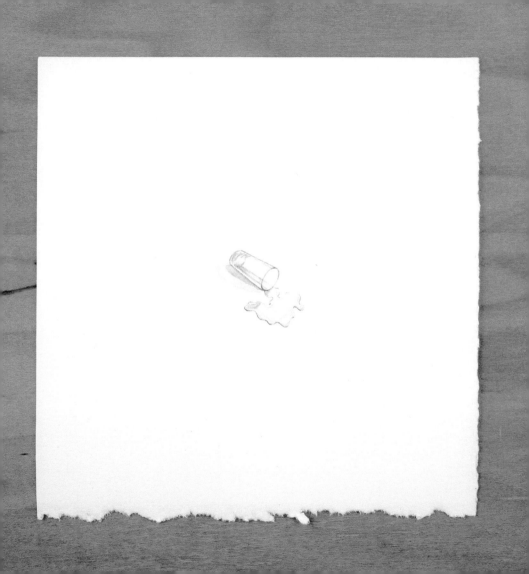

working from home
the wood kiln
creative camaraderie

November 8, 7:43 am

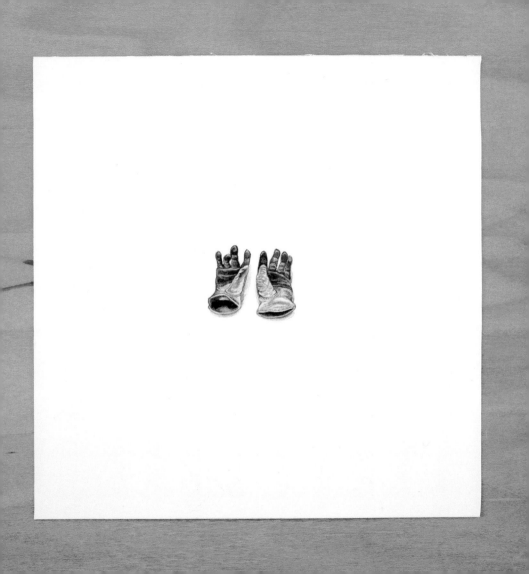

a nighttime walk
candle light
cousins

November 13, 10:13 am

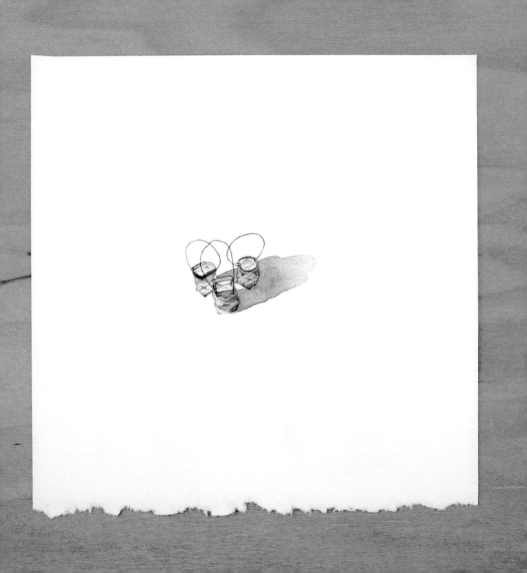

time with my kids
music classes
the part where we lie down

November 20, 9:48 am

having enough
family willing to travel
reasons to gather

November 28, 11:53 am

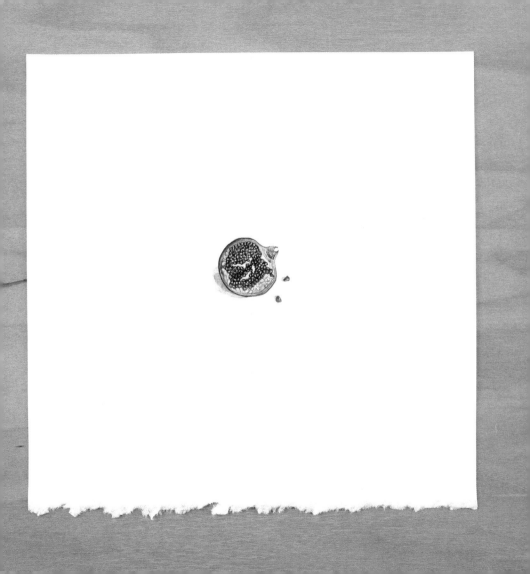

the people in my life
our similarities and differences
belonging

December 8, 9:47 am

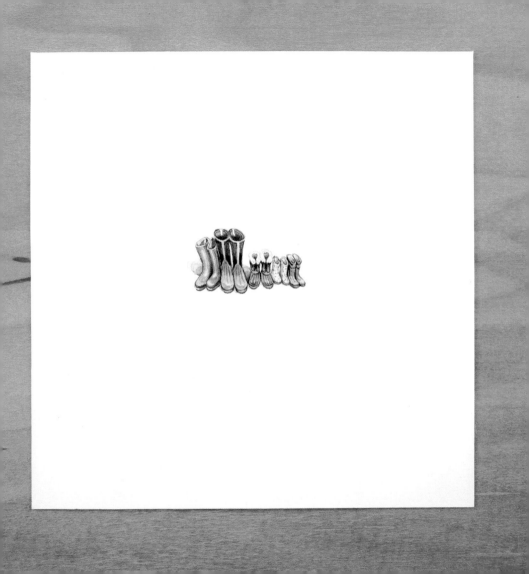

each person's unique path
contemplative space
how light grows

December 11, 1:24 pm

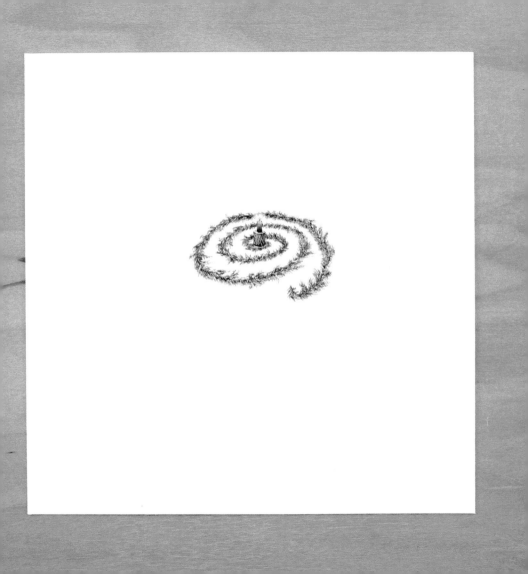

family recipes
holiday preparations
anticipation

December 22, 9:48 am

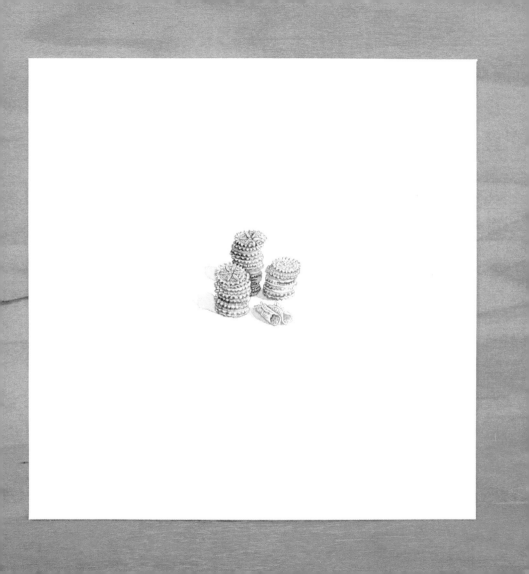

evergreens
persistence in the midst of challenge
reminders of spring

December 27, 10:40 am

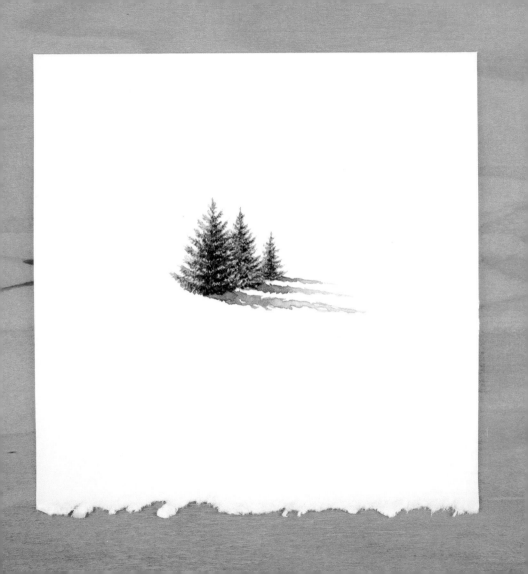

index of images

Acknowledgments

My deepest thanks to:

Everyone at Parallax Press who made this book experience such a delight.

Rachel Neumann, for all the thoughtful, encouraging conversations and her gentle guidance.

Grant Beachy, for his patience and vision while beautifully photographing so many tiny things.

Lucas Swartzendruber Landis, for graciously capturing moments with my family and time in the studio.

Barbara Davis and the International Guild of Miniature Artisans, for supporting my career from the very start.

Kathryn Gremley and the Penland School community, for validating my approach to miniature painting and supporting our family's creative life.

The creative women who inspire me: Mary Ann, Rachel, Anne, Sarah, Kristi, Leah, Courtney, Dana, Becky, Dawn, Jen, and Elise.

The Martin and Hochstetler families, who welcome us into their lives, make our children feel loved, and help make it possible for me to paint.

Taylor and Sadie, for helping out in so many ways, including the Muki walks.

Kirsten, Lora, Deb, and Janna, for sharing their encouragement, love, and families.

Lin, for her listening ear, compassionate heart, and steady voice of calm.

The Assembly Mennonite Church community, whose integrity, compassion, and passion for justice are a foundation in my family's life .

Arden, Meribeth, Nadia, and Ella, for their thoughtful encouragement and family support.

Geoff, for inspiring me to draw like him.

My parents, for their support and kindness in so many ways and for nurturing a love of details in life and art.

Layton, Linden, and Bryn for inspiring, challenging, and laughing with me, and for their love and patience as I figure out what it means to work from home.

Most of all to my dearest friend Justin, for his unparalleled support and care, which allows me the time to be creative each day and helps keep all the moving parts of work and family life in line. It is an honor and a pleasure to share life with you.

Brooke Rothshank is a studio artist from Goshen, Indiana. She and her husband, Justin Rothshank, a potter, share a workspace in their rural home studio. Brooke began painting dollhouse miniatures in 2005 after a scholarship to attend the International Guild of Miniature Artisans introduced her to $\frac{1}{12}$ scale painting. She is a Fellow member of IGMA, where she has taught summer classes and was awarded an independent study grant. Her current miniature work is primarily watercolor, making it easy to start, stop, and clean up during her morning studio hours. She enjoys quirky miniature commissions and collaborative projects. When she is not painting, Brooke has fun exploring the backyard woods with Justin and their three kids.

Related Titles

The Berkeley Bowl Cookbook, Laura McLively

Divine Gardens, Mayumi Oda

Drawing Your Own Path, John F. Simon, Jr.

Happy Veggies, Mayumi Oda

How to Love, Thich Nhat Hanh

Leading with Love, Hisae Matsuda and Maude White

Moments of Mindfulness, Thich Nhat Hanh

A Way of Life, Paul Davis

**PARALLAX
PRESS**

Parallax Press, a nonprofit publisher founded by Zen Master Thich Nhat Hanh, publishes books and media on the art of mindful living and Engaged Buddhism. We are committed to offering teachings that help transform suffering and injustice. Our aspiration is to contribute to collective insight and awakening, bringing about a more joyful, healthy, and compassionate society.

For a copy of the catalog, please contact:

Parallax Press
P.O. Box 7355
Berkeley, CA 94707
parallax.org